Other LAUGHTER DOODLES Coloring Books
by Sarah Routman

LAUGHTER DOODLES - A Coloring Book That Makes You Happier

LAUGHTER DOODLES - A Coloring Book to Inspire You

The ABC's of LAUGHTER - A **LAUGHTER DOODLES** Coloring Book to Help You Make an Awesome Attitude Adjustment

FAMILY FRIENDLY 4-LETTER WORDS

All rights reserved. No portion of this book may be used or reproduced in any manner whatsoever without written permission from the author.

All the words in this book can be purchased as individual pages. I will be happy to create your favorite 4-letter word or any word. Words can also be created as cards or postcards. Contact me to begin your custom order.

Sarah@LaughHealthy.com

Sarah Routman

Follow me on Facebook:
'Like' https://www.facebook.com/laughterdoodles

Find my photographs at
www.ThroughSarahsEyes.com

"Like" https://www.facebook.com/Through-Sarahs-Eyes-651770878363771/

Learn about Healthy Laughter at
www.LaughHealthy.com

Copyright © 2019 Sarah Routman
All rights reserved.
First Edition
ISBN: 9781096251149

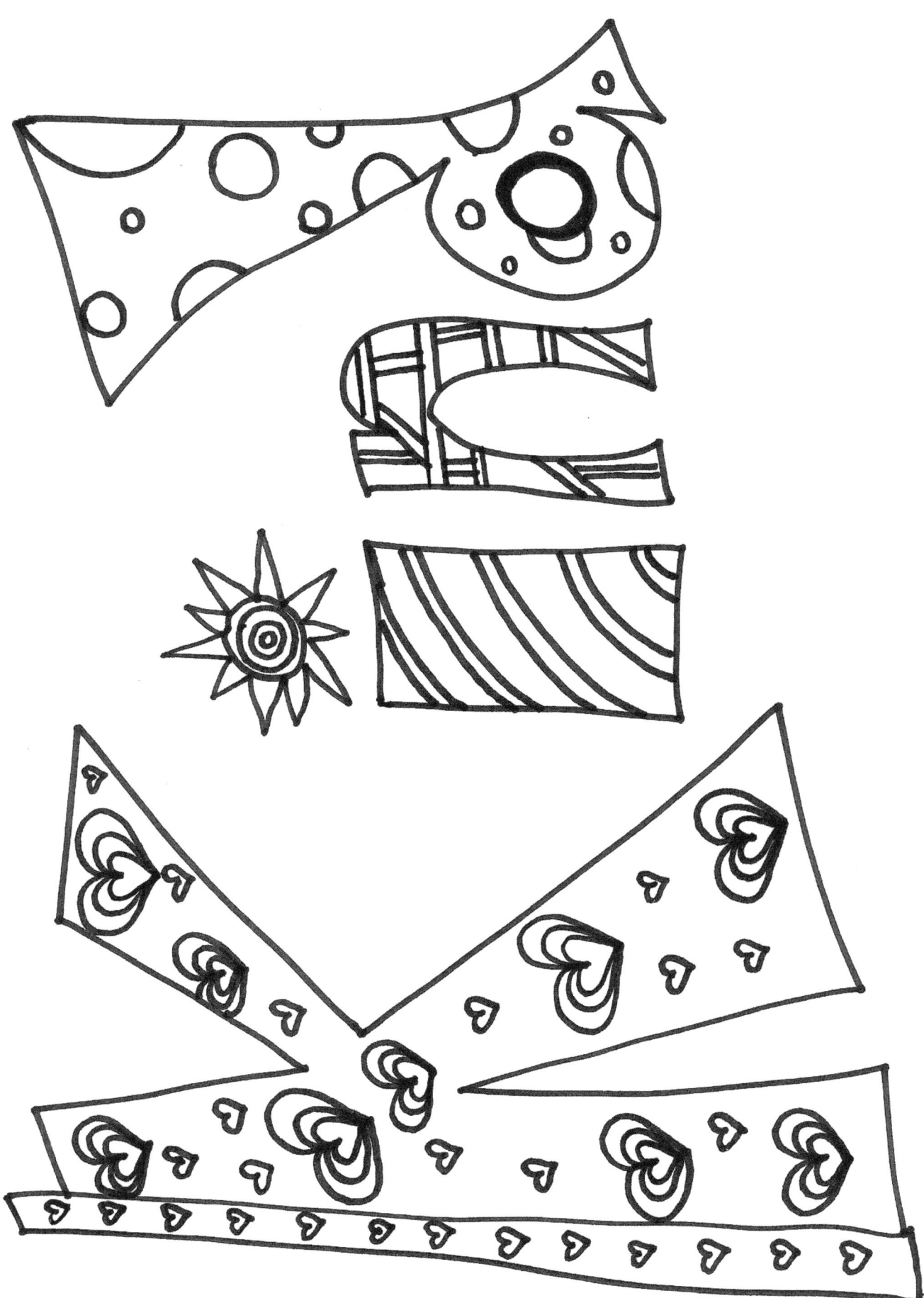

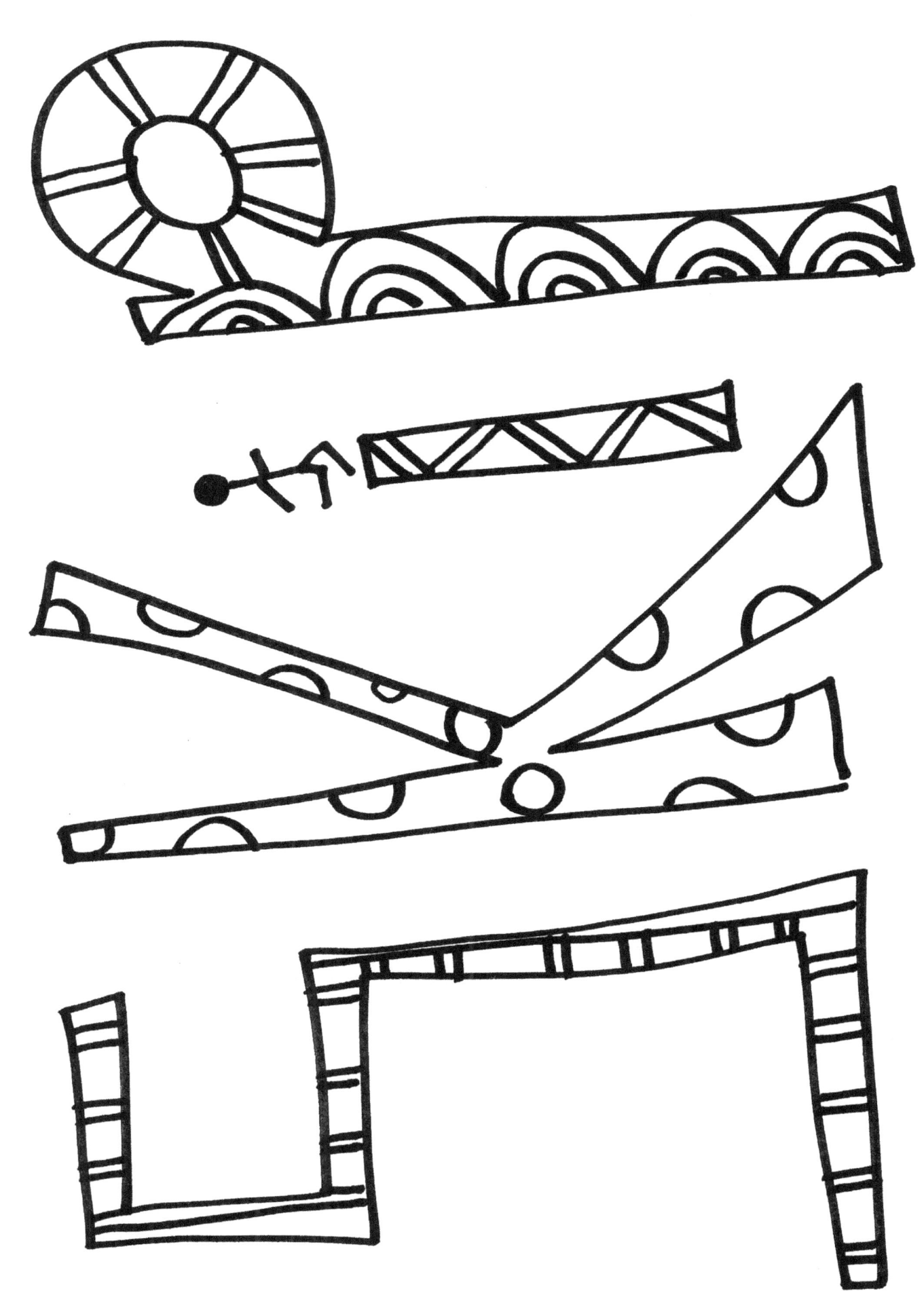

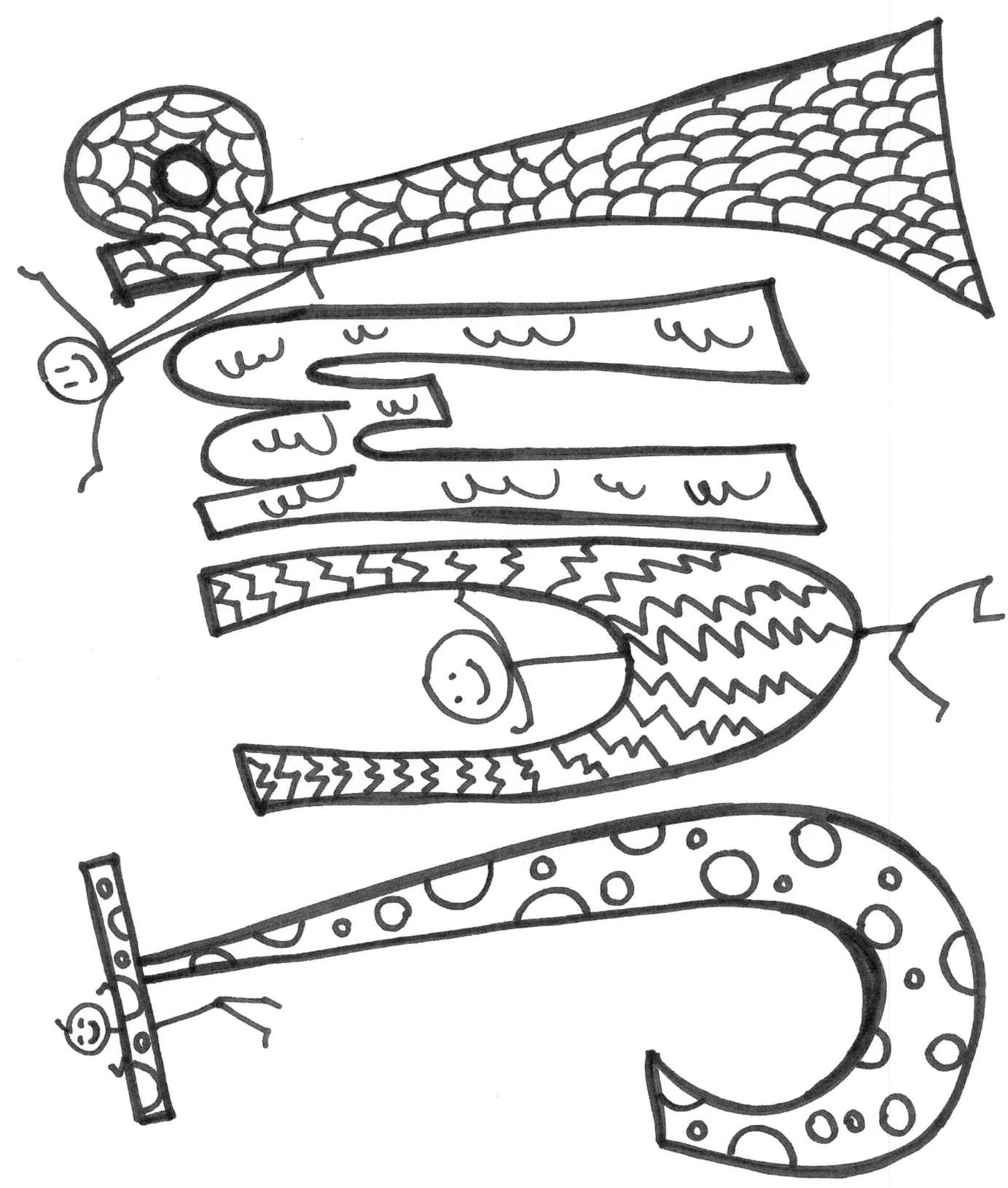

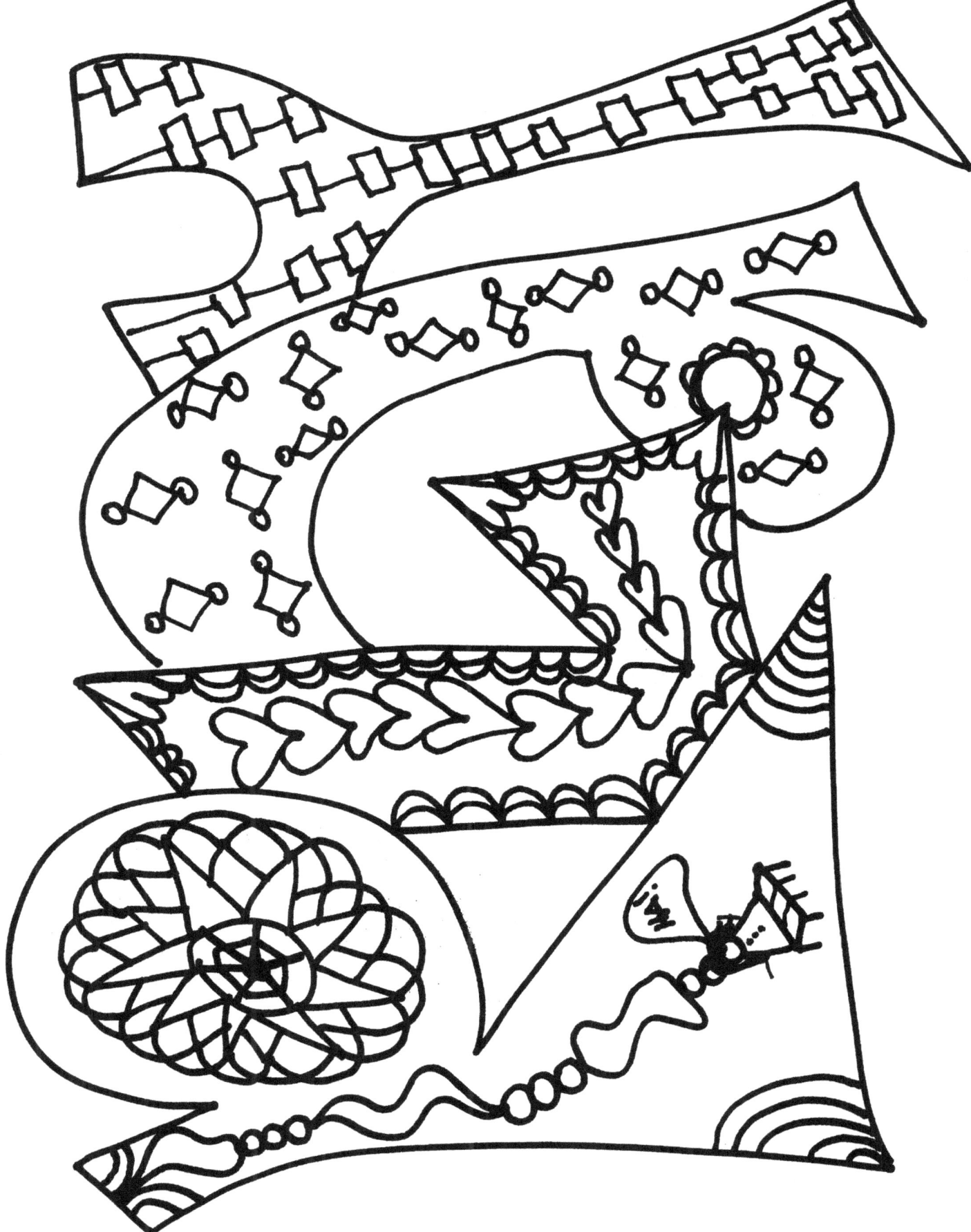

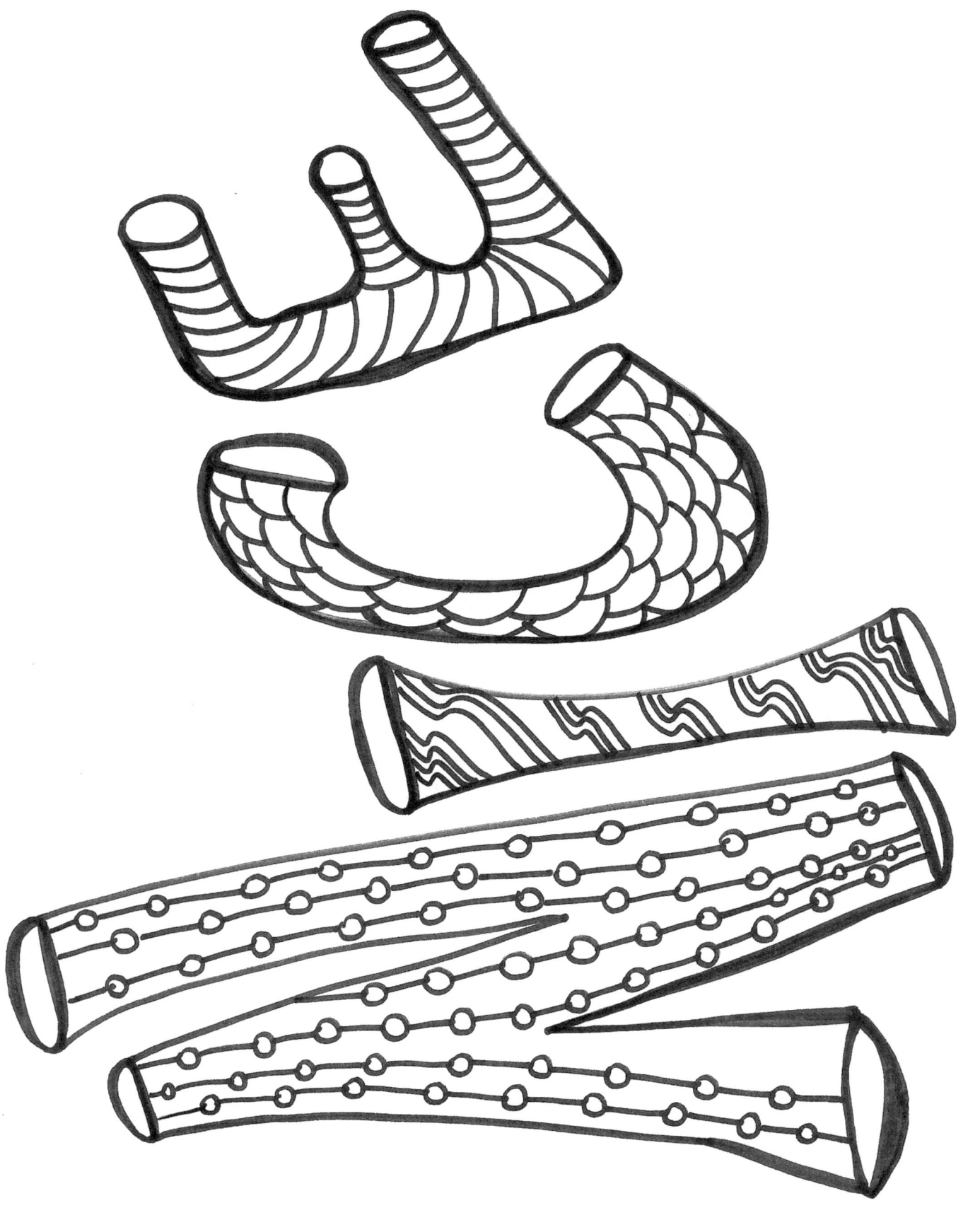

www.ingramcontent.com/pod-product-compliance
Lightning Source LLC
Chambersburg PA
CBHW081018170526
45158CB00010B/3082